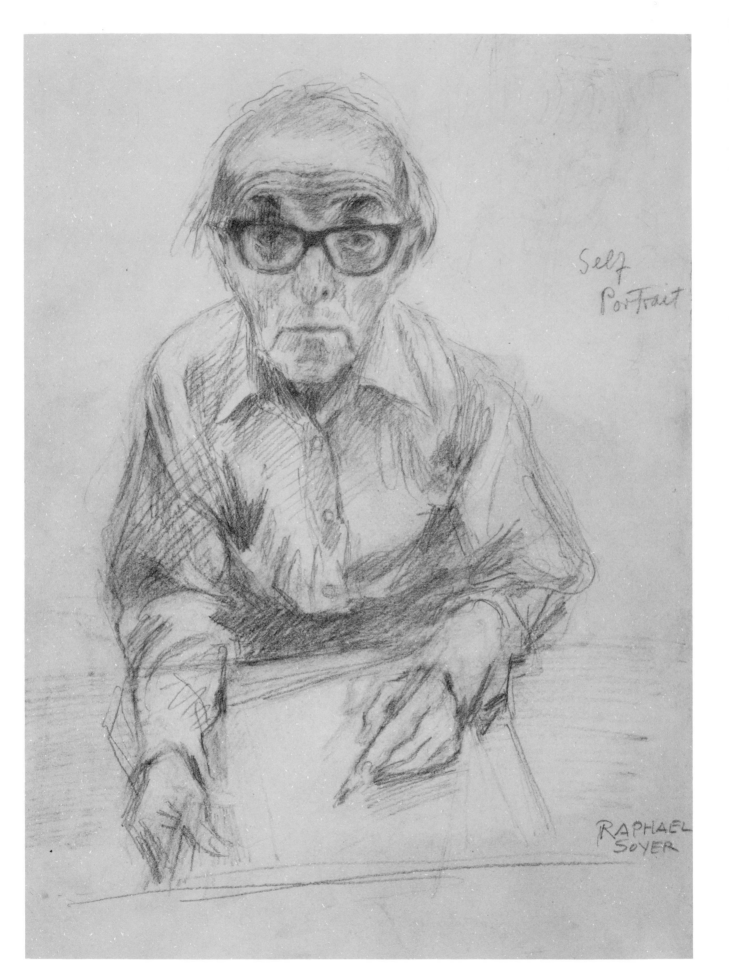

Self
Portrait

RAPHAEL
SOYER

RAPHAEL SOYER
Life Drawings and Portraits

43 PLATES

Dover Publications, Inc., New York

FRONTISPIECE: Self-Portrait. 1950s. Pencil; 19 × 12½ inches.

Published in Canada by General Publishing Company, Ltd., 30 Lesmill Road, Don Mills,
Toronto, Ontario.
Published in the United Kingdom by Constable and Company, Ltd.

Raphael Soyer Life Drawings and Portraits is a new work, first published by Dover Publications, Inc., in 1986. All drawings are reproduced directly from the originals. The drawings were selected in close consultation with the artist from among those in his personal collection and were lent for reproduction courtesy of Bella Fishko, Director, Forum Gallery, New York. The Introduction by the artist is an adaptation of a statement originally prepared for an exhibition at the University of Georgia, Athens, in 1968.

Manufactured in the United States of America
Dover Publications, Inc., 31 East 2nd Street, Mineola, N.Y. 11501

Library of Congress Cataloging-in-Publication Data

Soyer, Raphael, 1899–
Raphael Soyer—life drawings and portraits.

1. Soyer, Raphael, 1899– —Catalogs. 2. Nude in art. 3. Portraits. I. Title.
NC139.S633A4 1986 741.973 85-29311
ISBN 0-486-25100-4

INTRODUCTION

As far back as I can remember my brothers and I always drew, and our father, a teacher and writer, was a skillful draftsman. When I was about seven or eight years old, a young neighbor of ours would often visit our father to show him his oversized drawings. One day he asked my father to pose for him and he drew him as I watched. That one could draw a living person was a sudden revelation to me. For some time I stopped drawing altogether and then I asked my father to sit for me as he had for our neighbor. I drew his face, and the drawing was praised and considered a good likeness. My elation was boundless. I became a confirmed realist; I drew only from nature. I didn't draw from imagination anymore like other children.

As time went on, I made more discoveries. There was a woods in the outskirts of the town to which our father would take us on Sundays to picnic and draw. He was our "progressive" teacher and we were his "perceptive" pupils. I was, even in those days, fascinated—in a childish way, I suppose—by space and perspective. But I was always frustrated by my inability to indicate on paper the difference between the trees close to me and those far from me. One day I saw a picture of a forest in a magazine and I noticed that the nearer trees began at the bottom of the paper and as the trees receded, the farther up the paper they were. How this illusion of distance from tree to tree was effected was another revelation to me. I made many drawings of our woods according to this guideline and never ceased to wonder at the space and distance I was able to create on the flat surface of the paper.

Again, I discovered that by shading one can give the impression of a third dimension of roundness and solidity. And once, in making a picture of the ever-present rubber plant, I added some green watercolor to the leaves and was startled by the additional touch of reality this gave to my drawing. I was acquiring the habit of drawing the visible world and, with it, the discipline that comes from daily application.

Thus, by 1914 (when according to the records on file, I found myself in the evening classes at Cooper Union), I, the insecure foreigner, felt equal among my older peers when I sat down to work with my charcoal. There I saw my first nude model, and I gasped at the undulating line and the vitality in the movement of the female figure as she ran up the model stand.

At present, the idea is prevalent that one does not have to be able to draw in order to be an artist—that color, metier, the element of abstraction are sufficient and that drawing, which Ingres called "the probity of painting," is superfluous. In art schools and in the art departments of universities, a brief period of attention is given to drawing from life, from still-life, from trees and plants, etc. The ultimate goal, however, is non-representationalism of any variety. To me this is a preposterous state of affairs. To be an artist without skill in drawing is inconceivable. I like the way Cézanne *drew* his face in the paintings of his self-portraits and the faces and figures in his Card Players.

Can one imagine the art of Van Eyck, Rubens, Holbein and Dürer, Ingres, Delacroix and Degas without the element of drawing? As a matter of fact, artists, when they wrote about art in their letters, diaries and journals, were most adamant in their insistence upon knowledge of drawing. Van Gogh, in a letter that always moves me, wrote that he is drawing all the time and is making progress.

Ingres said, "Drawing is everything, the rest is hue." Tintoretto expressed the same thought—"Beautiful colors are for sale in the shops of the Rialto, but good drawing can only be fetched from the casket of the artist's talent, with patient study and sleepless nights." And Michelangelo, when the Pope admired his craft and conception, said, "It is a matter of good drawing. All the rest you can get by pissing upon it."

Long ago the streets of New York were my studio. I went out to draw the people in the parks, on the bridges, on the piers. Today New York is monstrous and inaccessible and I am older. I bring the world into my studio. The content of my work remains the same—people.

I love to draw and I draw constantly for the sake of drawing. I also make numerous studies in pencil and watercolor for my oil compositions. These drawings are not only a record of my years of work, but I hope they are also, to some degree, a reflection of the life and condition of our times.

RAPHAEL SOYER

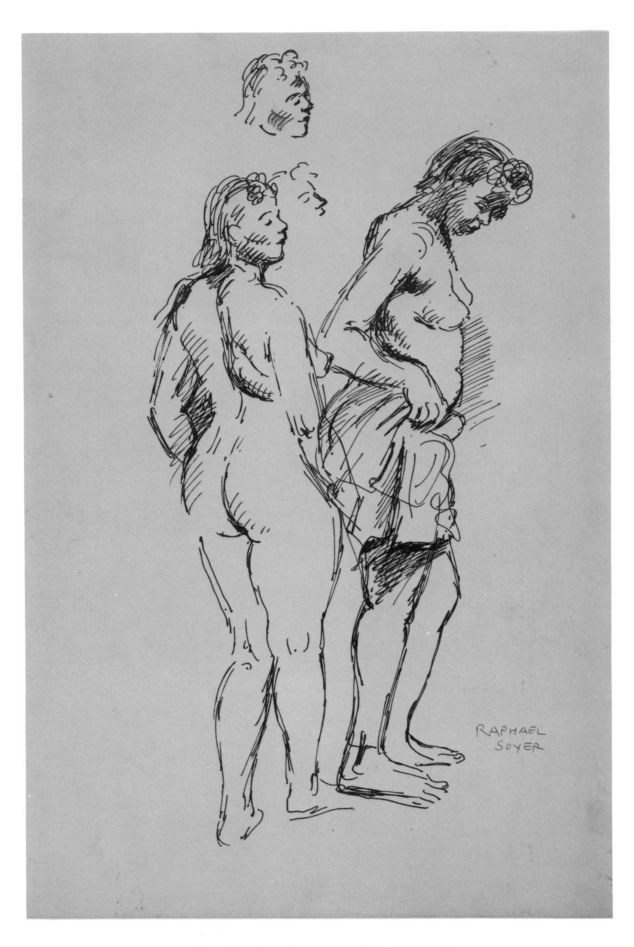

Studies of Nude Model. 1930s. Ink; 16¾ × 11 inches.

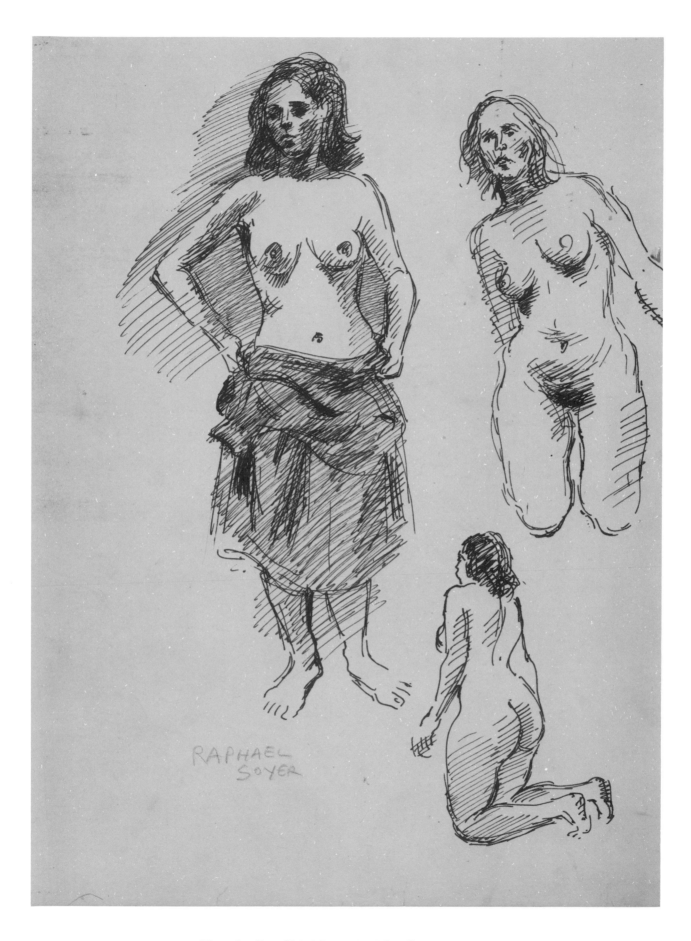

Three Studies of Model. 1930s. Ink; 16½ × 12 inches.

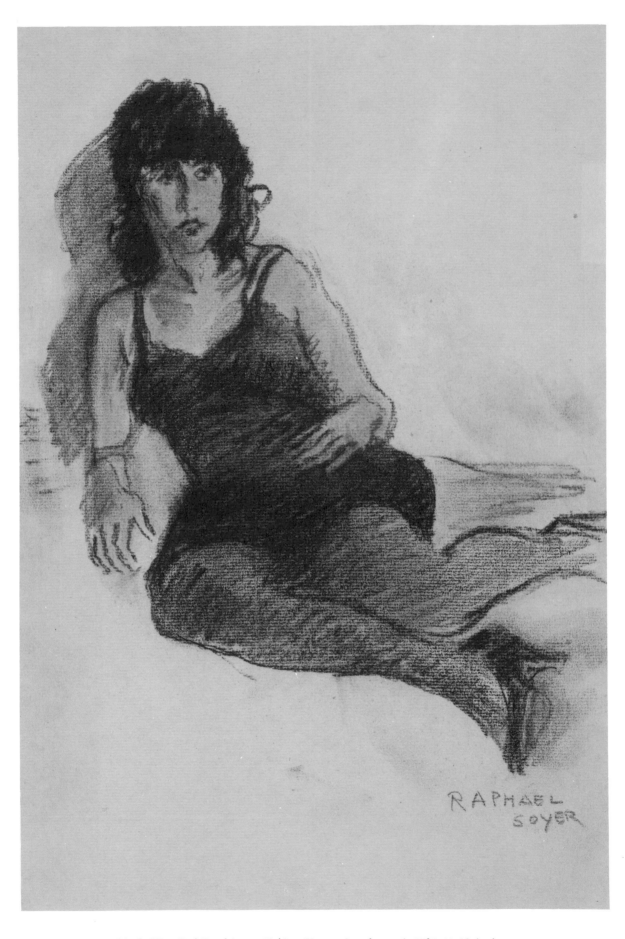

Black Slip, Red Stockings. 1940s. Charcoal and pastel; 17¾ × 12 inches.

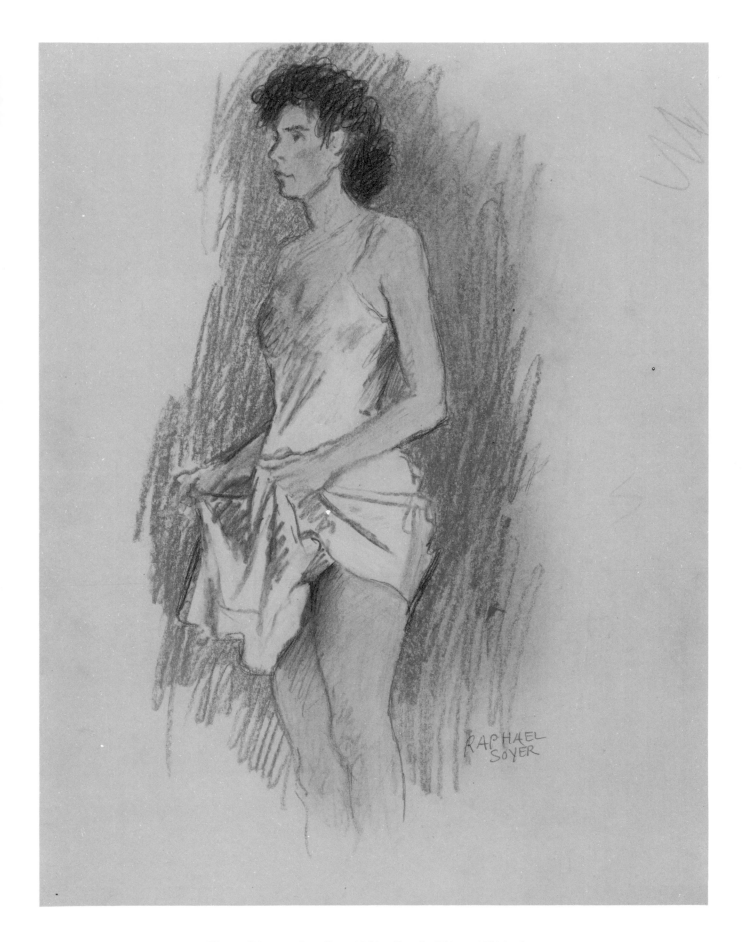

Young Woman, Standing. 1960s. Pastel; 19⅜ × 15¼ inches.

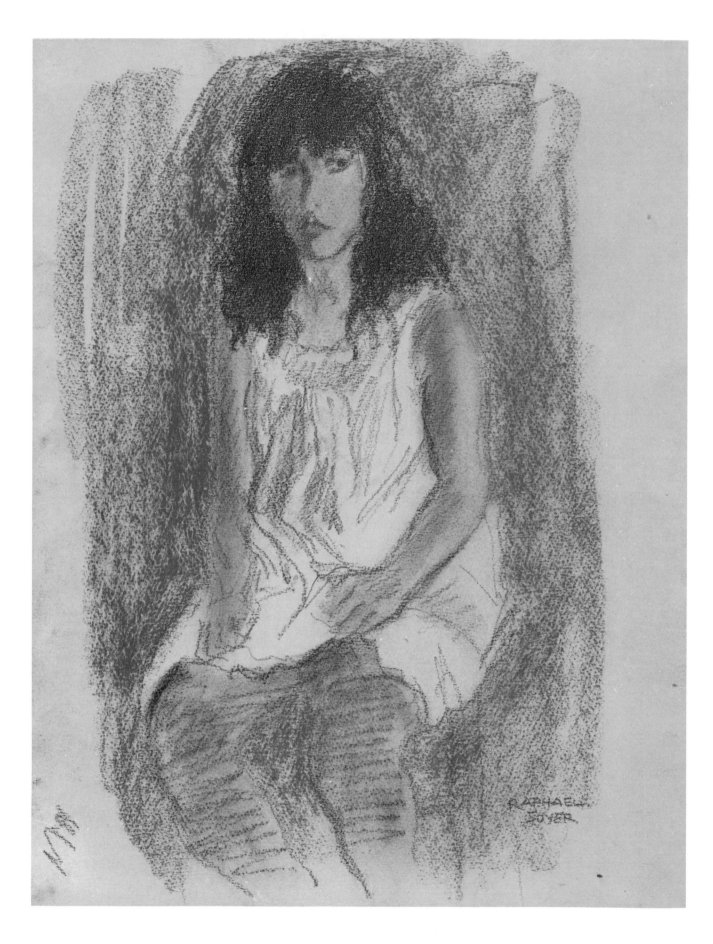

Model in Orange Stockings. 1950s. Charcoal and pastel; 18⅜ × 14¼ inches.

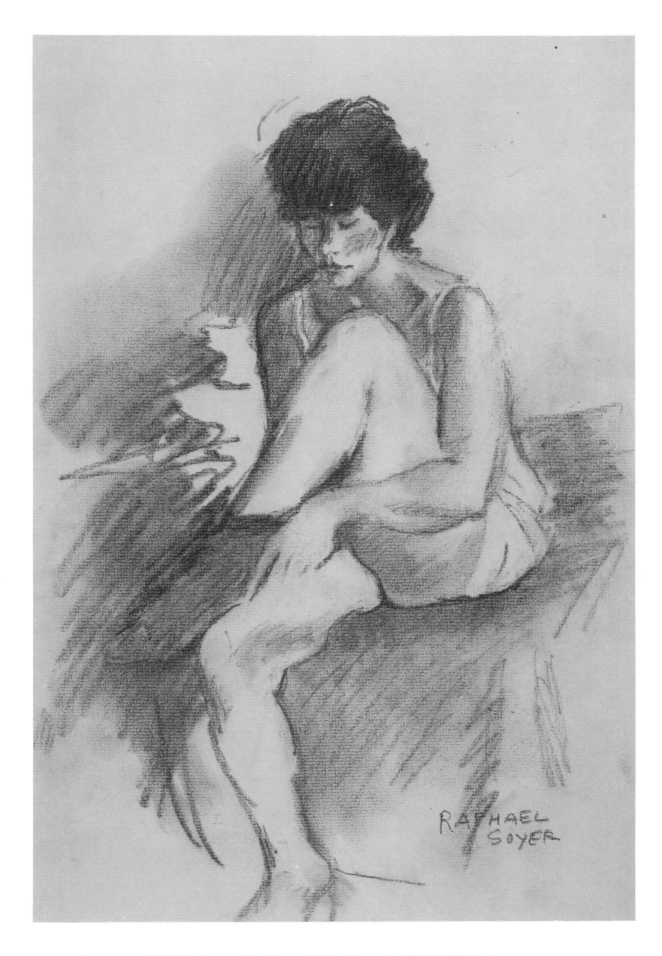

Model Pulling on Stockings. 1950s. Charcoal; 20¾ × 14¼ inches.

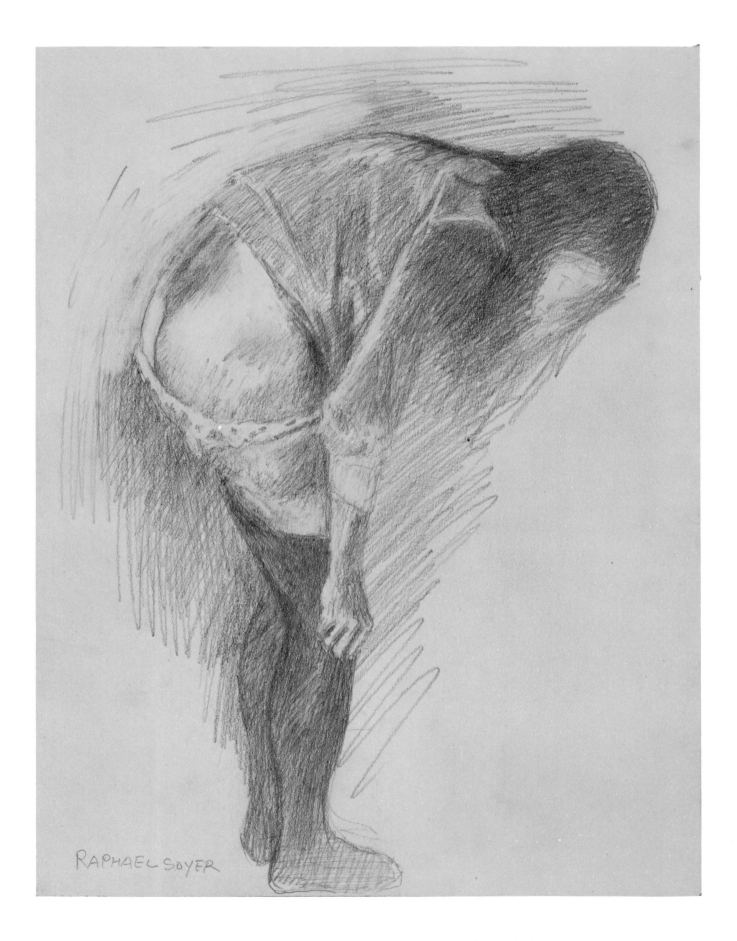

Girl Bending to Remove Stockings. 1950s. Pencil; 14 × 11 inches.

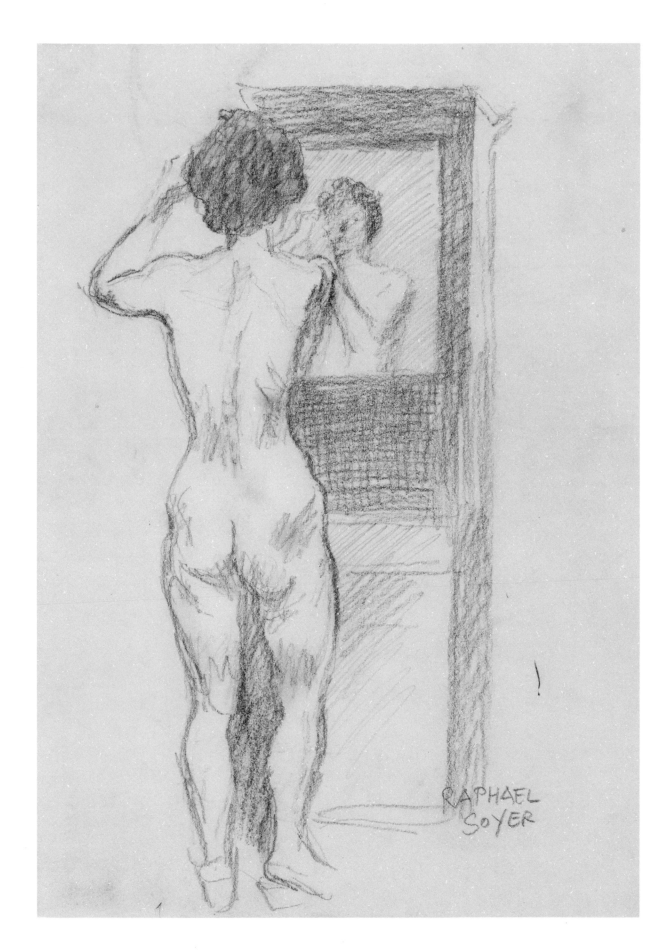

Nude Fixing Hair in Mirror. 1950s. Charcoal; 21⅞ × 15⅛ inches.

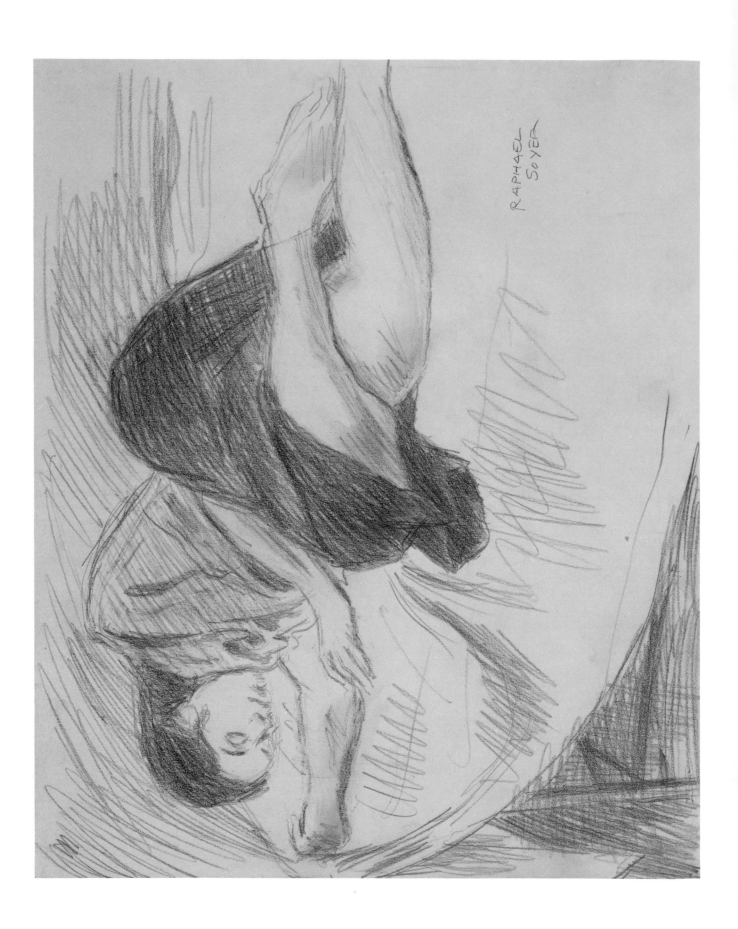

14

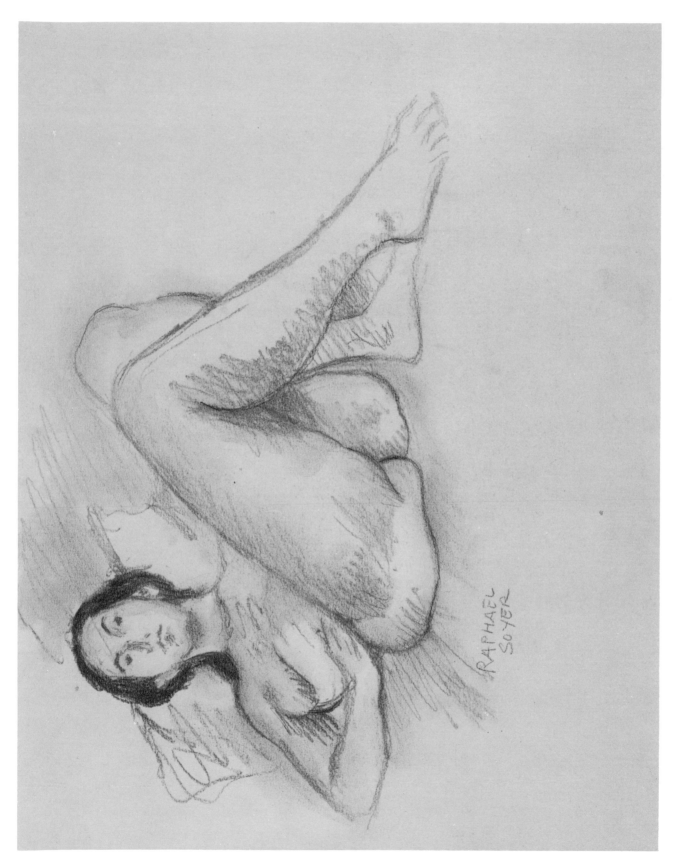

TOP: Sleeping Girl. 1950s. Pencil; 14 × 17 inches. BOTTOM: Nude with Raised Legs. 1950s. Charcoal; 14½ × 18 inches.

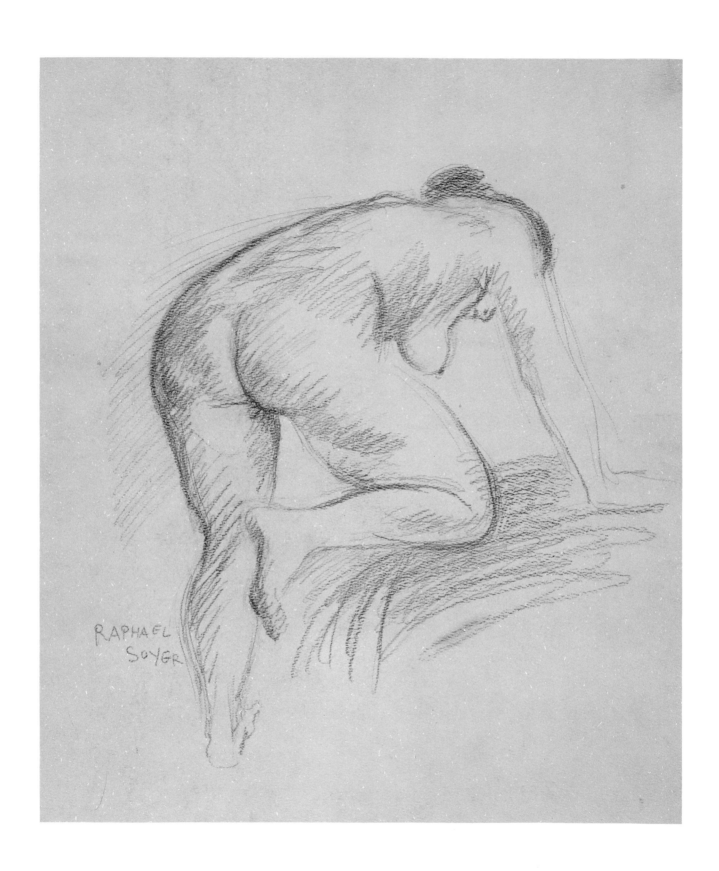

Nude Kneeling on One Knee. 1950s. Pencil and charcoal; 19 × 16¼ inches.

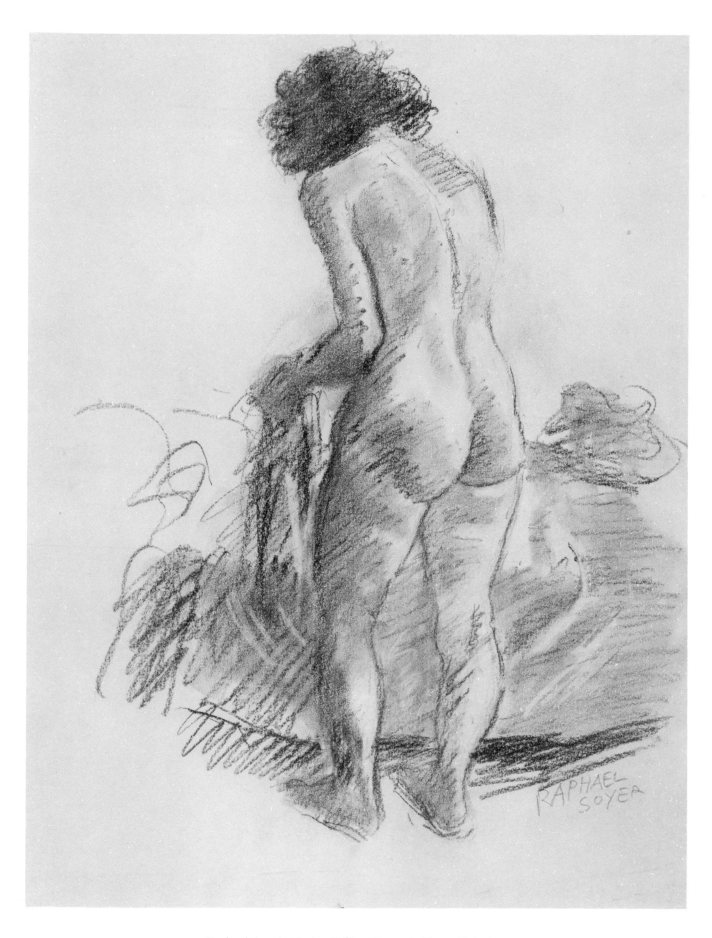

Back of Female Nude. 1960s. Charcoal; 18 × 15 inches.

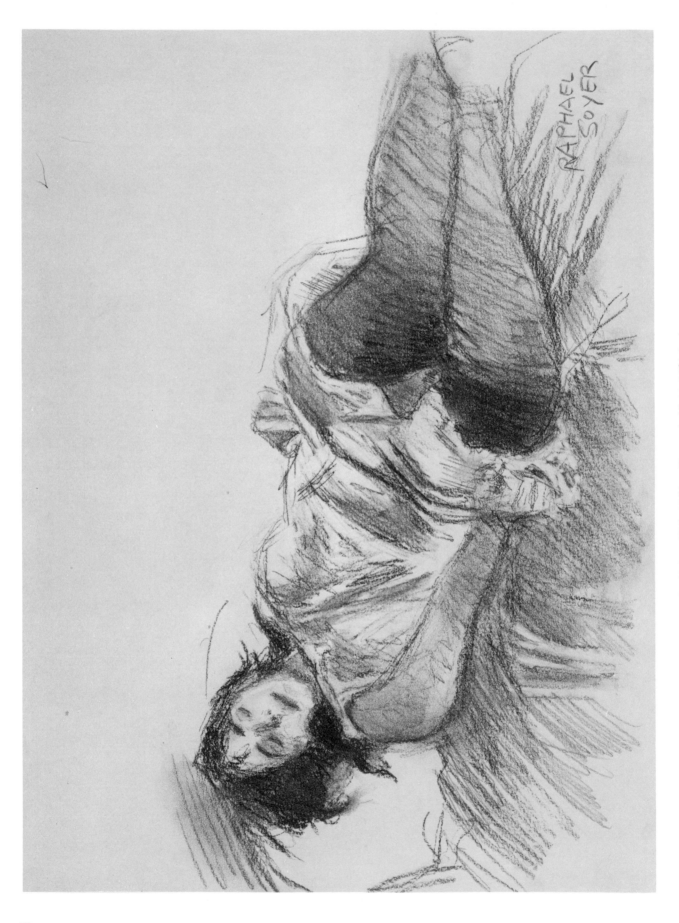

Reclining Girl. 1960s. Charcoal; 18 × 23¾ inches.

18

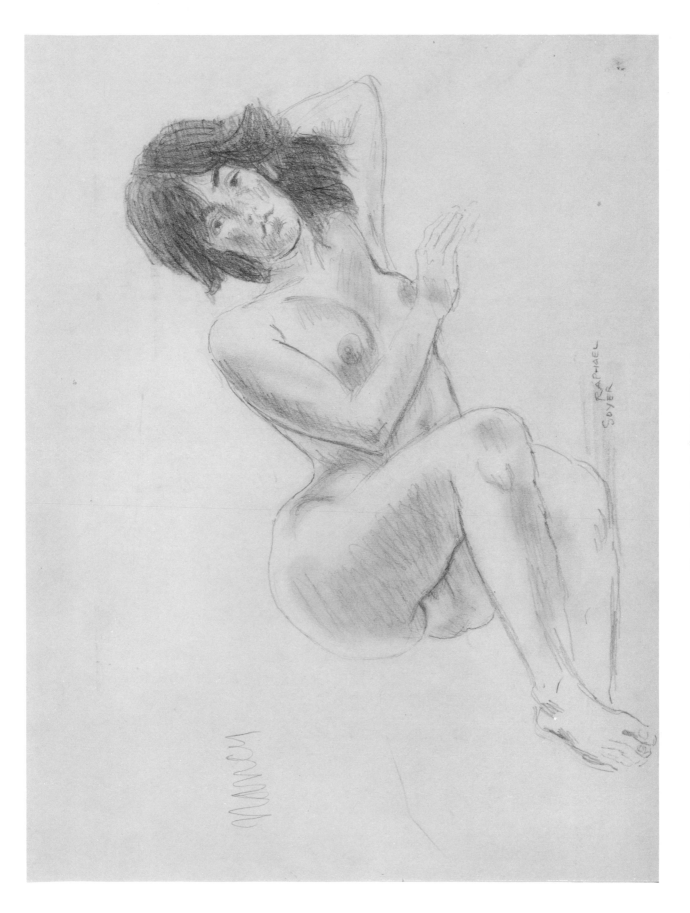

Nancy. 1950s. Pencil; 17¼ × 22⅛ inches.

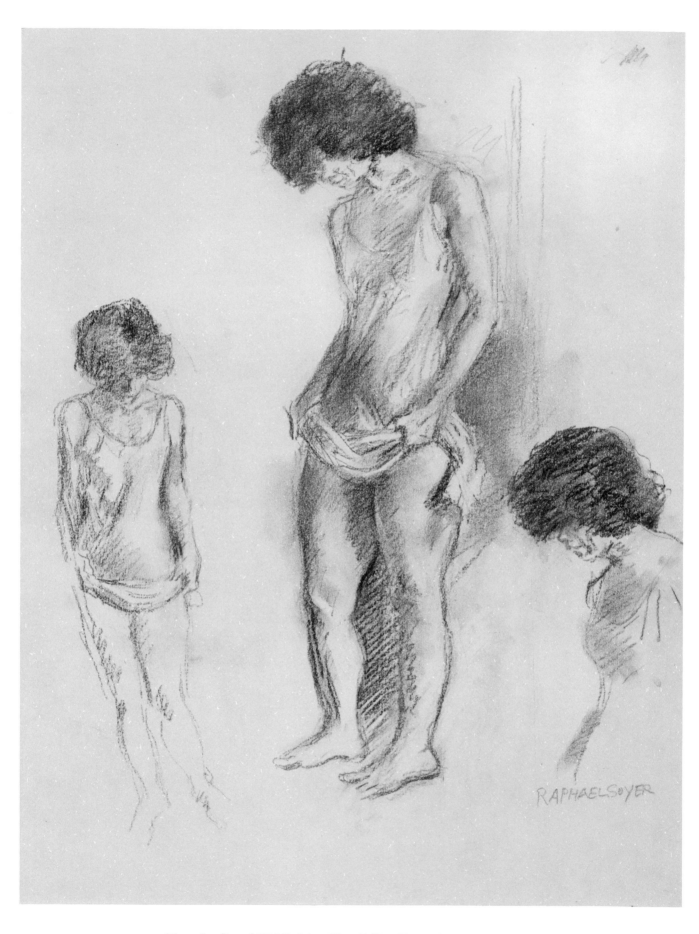

Three Studies of Girl Raising Slip. 1960s. Charcoal; 25 × 19 inches.

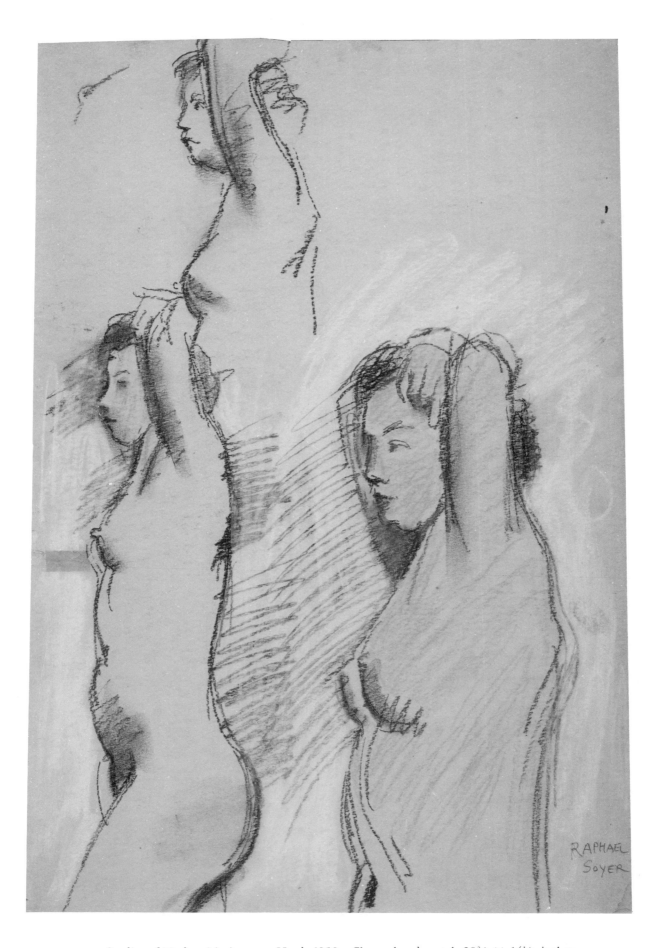

Studies of Nude with Arms on Head. 1950s. Charcoal and pastel; 20¾ × 14¼ inches.

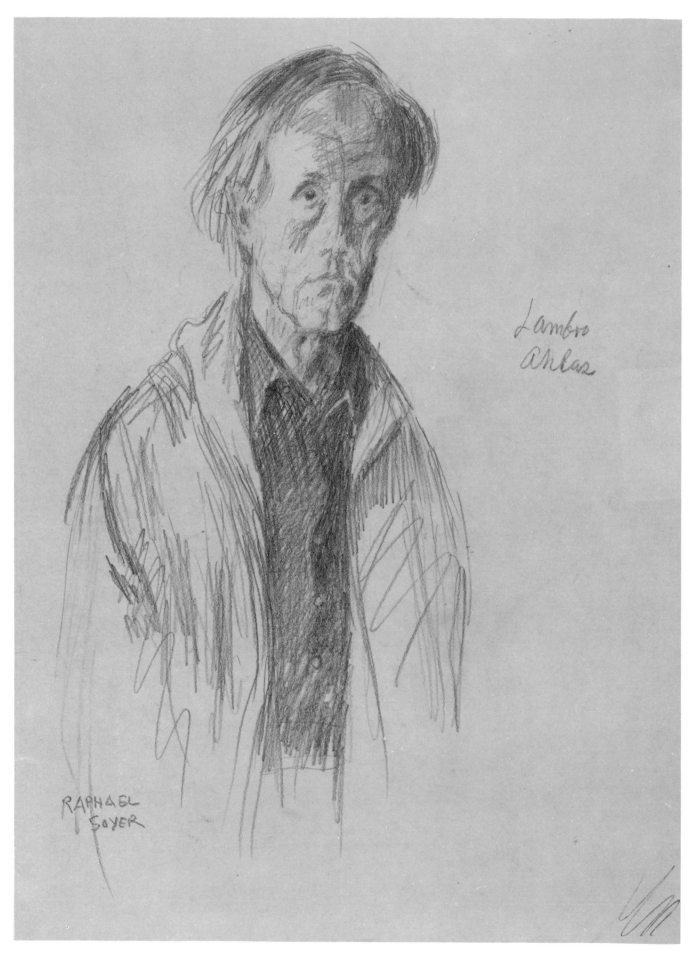

Lambro Ahlas

RAPHAEL SOYER

Lambro Ahlas. 1960s. Pencil; 14 × 11 inches.

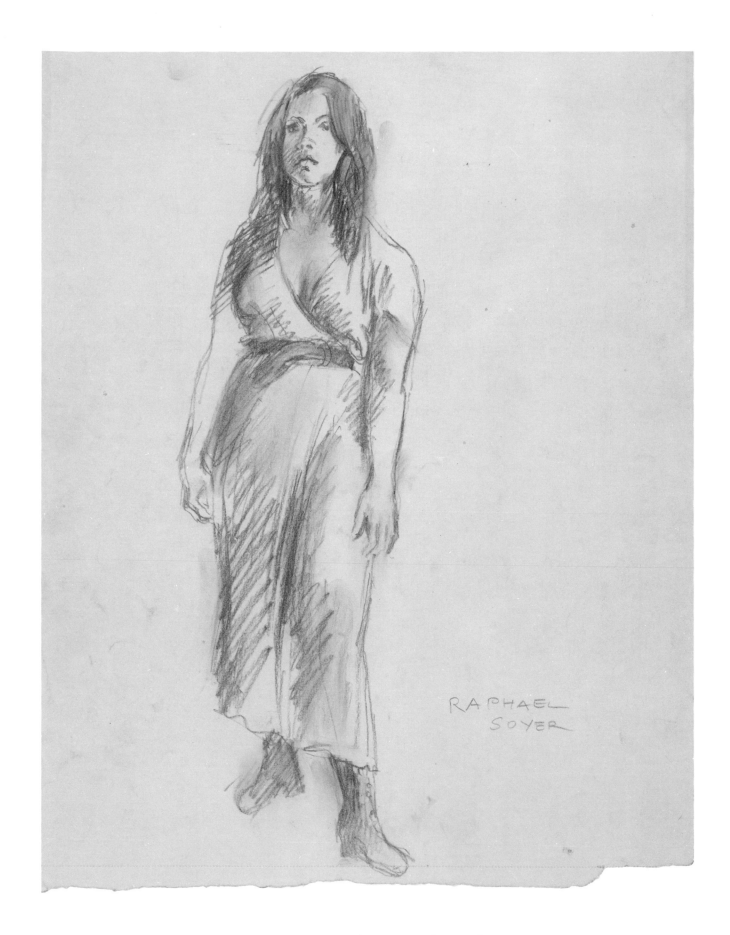

Young Woman, Standing. 1960s. Pastel; 19⅜ × 15¼ inches.

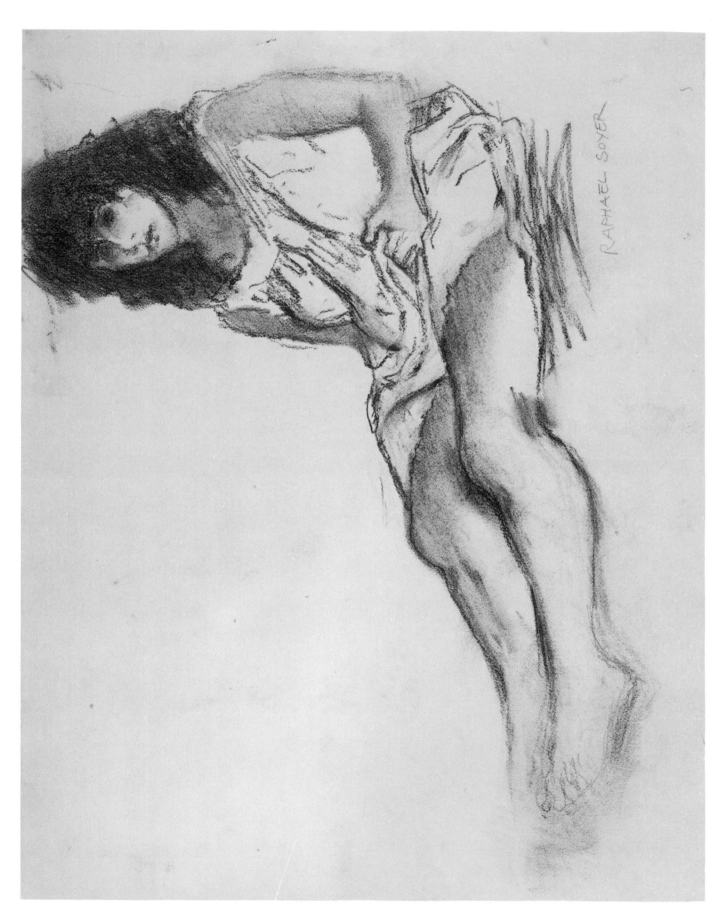

TOP: Model Sitting Up. 1960s. Charcoal; 19 × 24 inches. BOTTOM: Reclining Girl, Leg Raised. 1960s. Charcoal; 18 × 23¾ inches.

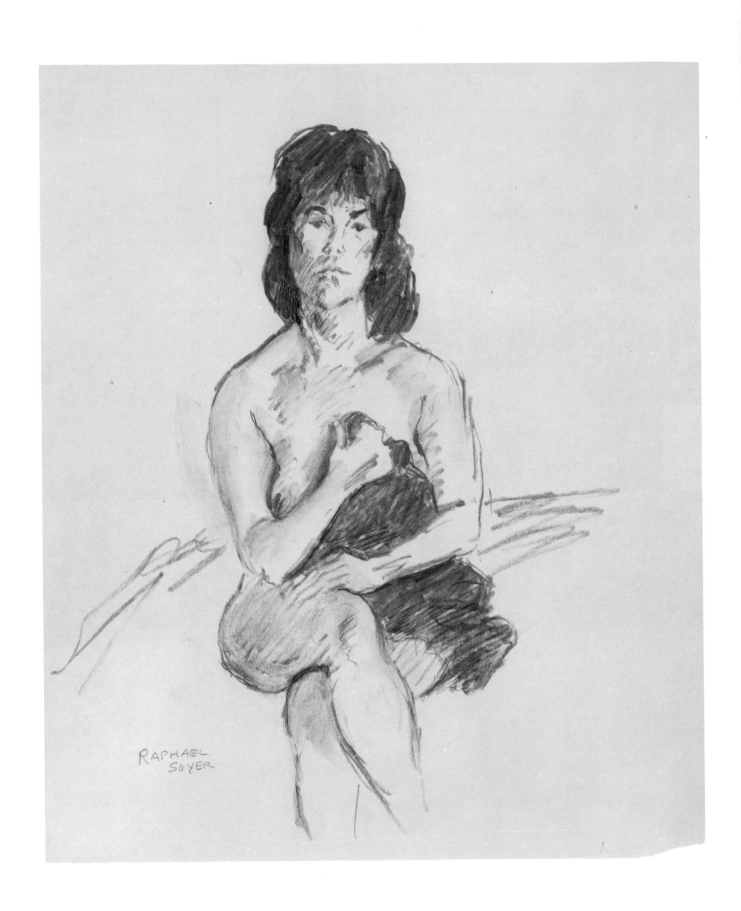

Seated Nude Clutching Clothes. 1950s. Charcoal; 18⅞ × 15¾ inches.

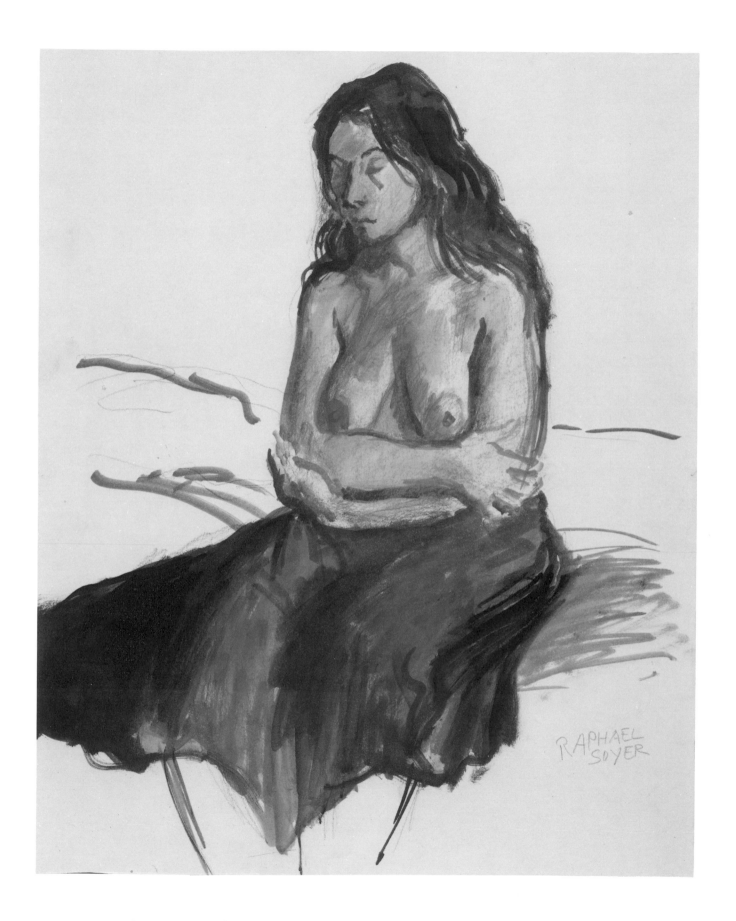

Woman in Blue Skirt with Folded Arms. 1970s. Pencil and watercolor; 23½ × 19 inches.

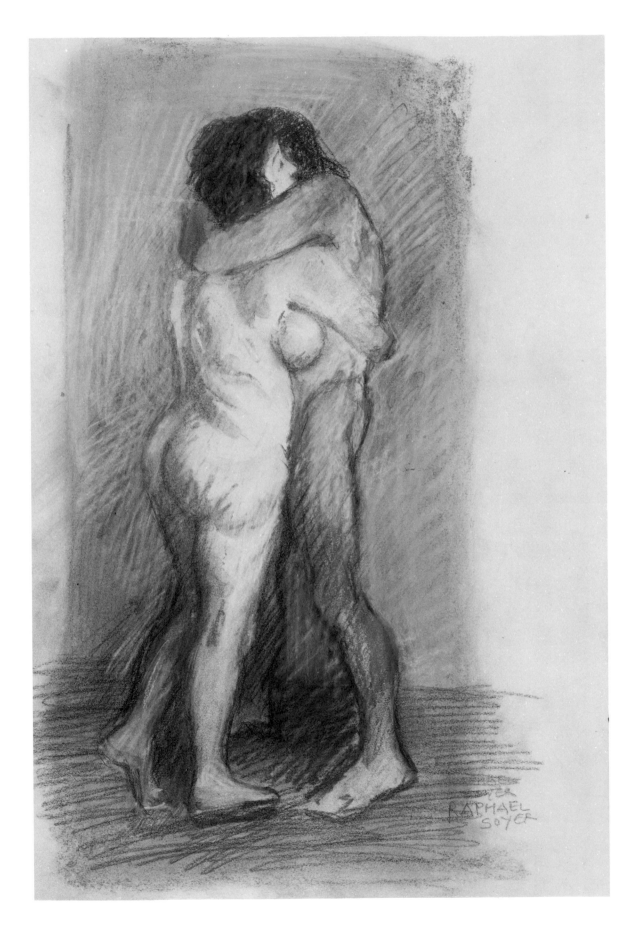

Nude Couple, Embracing. 1970s. Charcoal and pastel; 19⅝ × 13¼ inches.

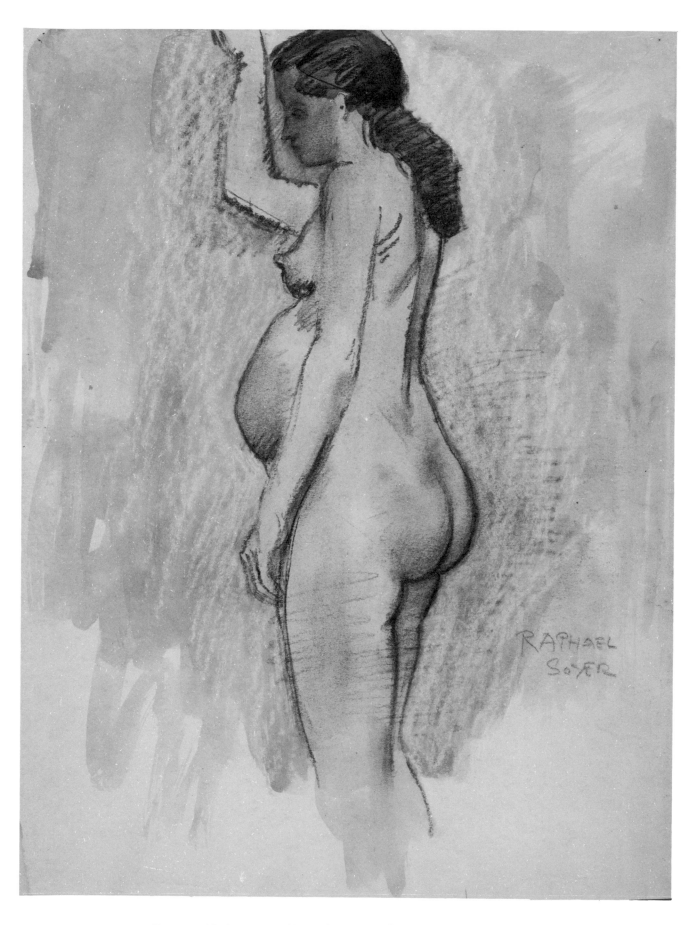

Pregnant Nude. 1950s. Charcoal, pastel and wash; 19½ × 14½ inches.

Studies of Nude (illustration for Isaac Bashevis Singer stories). 1970s. Pencil; 16½ × 22 inches.

for illustrations for I.B. Singer book

RAPHAEL
SOYER

Nudes (illustration for Isaac Bashevis Singer stories). 1970s. Pencil; 16¼ × 22 inches.

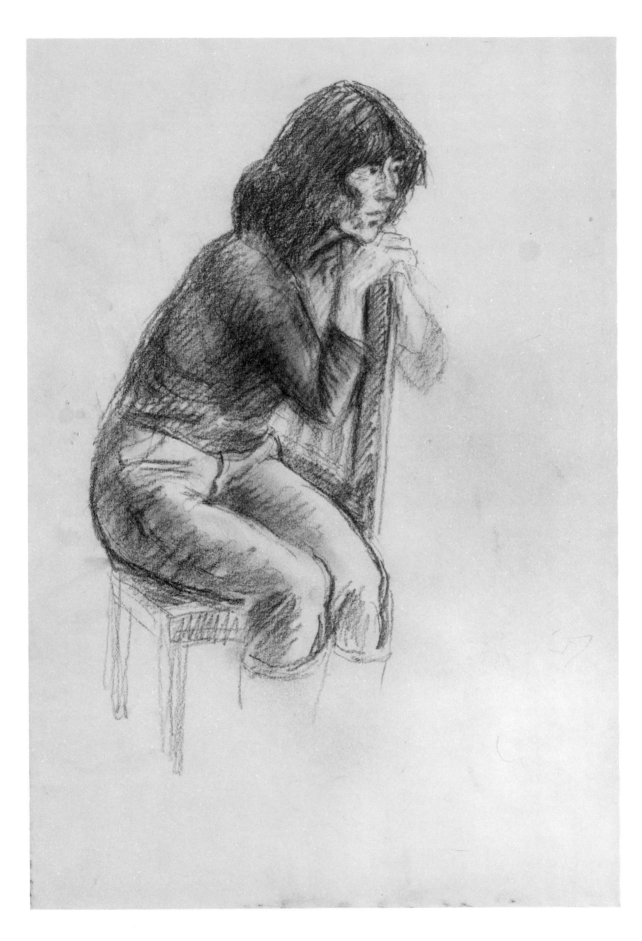

Seated Girl, Leaning on Chair Back. 1980s. Charcoal; 22 × 15⅛ inches.

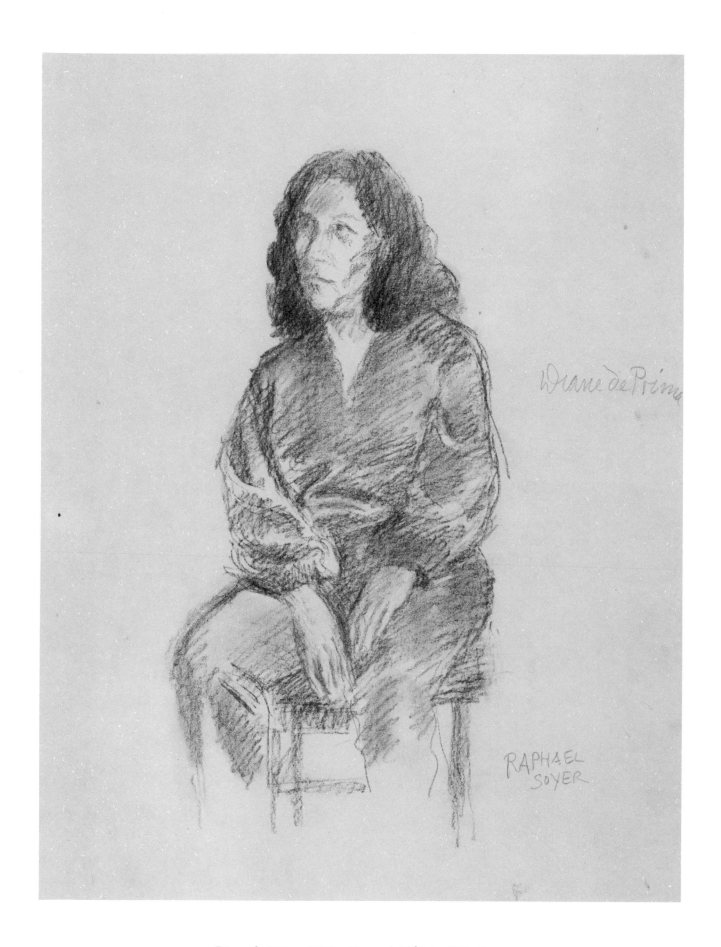

Diane de Prima. 1950s. Charcoal; 23¾ × 18 inches.

Rebecca, Head in Hand. 1980s. Charcoal; 14⅝ × 15¾ inches.

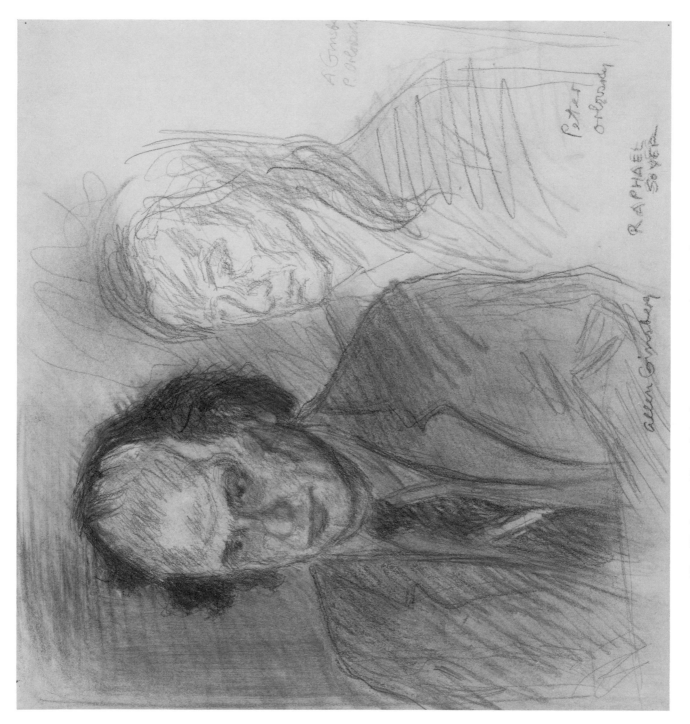

Allen Ginsberg and Peter Orlovsky. 1950s. Pencil and pastel; 14⅝ × 15⅜ inches.

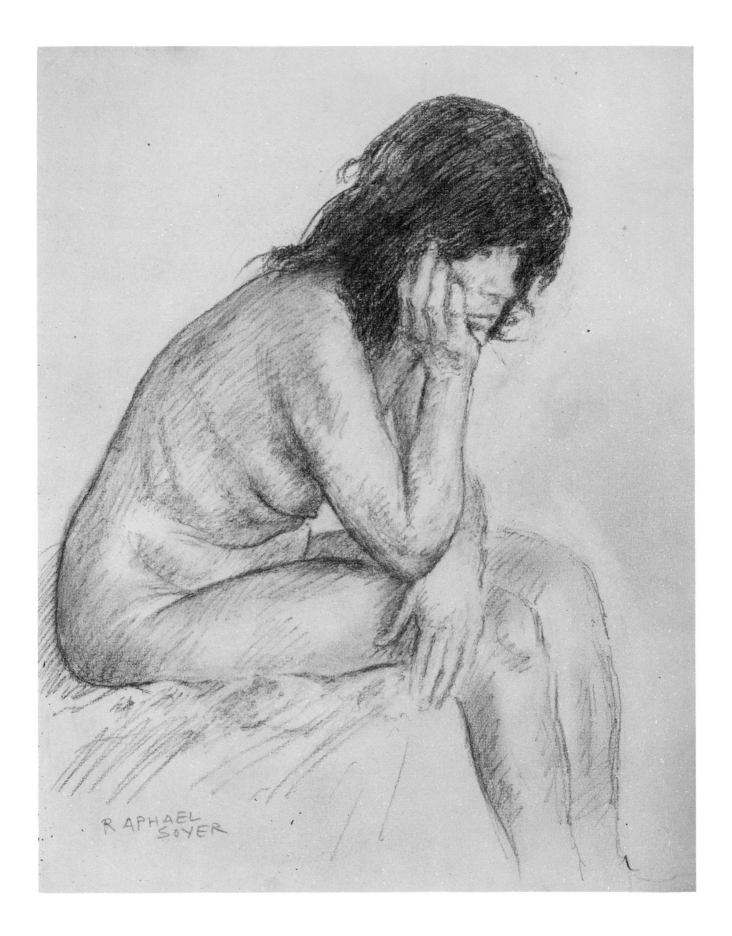

Seated Nude, Head in Hand. 1981. Pencil; 13⅜ × 10¼ inches.

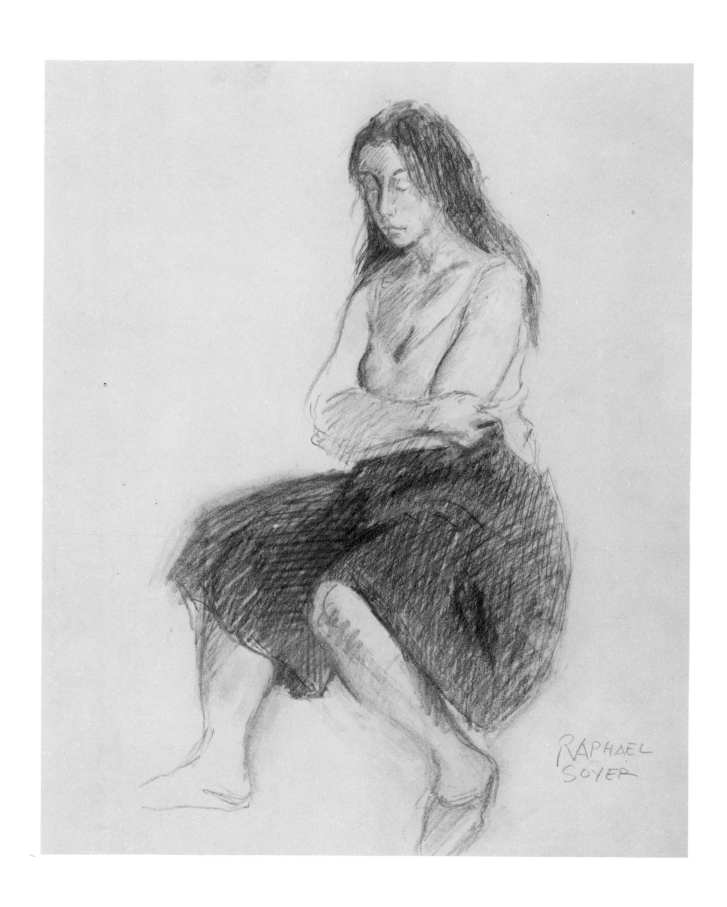

Seated Model with Folded Arms. 1970s. Charcoal; 18⅞ × 15¾ inches.

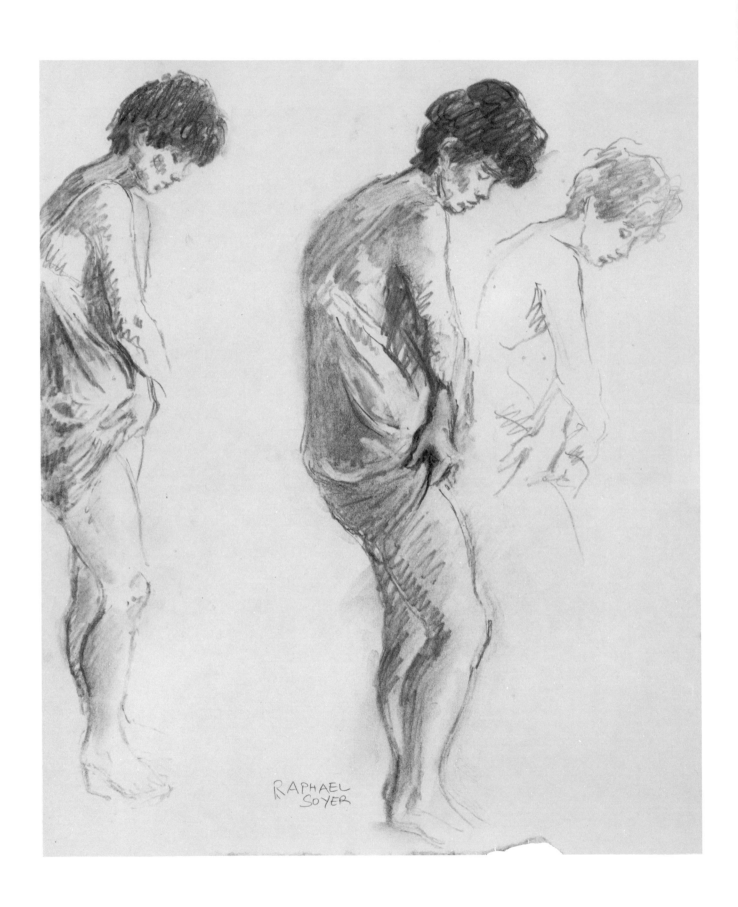

Studies of Model Disrobing. 1980s. Charcoal; 18⅞ × 15¾ inches.

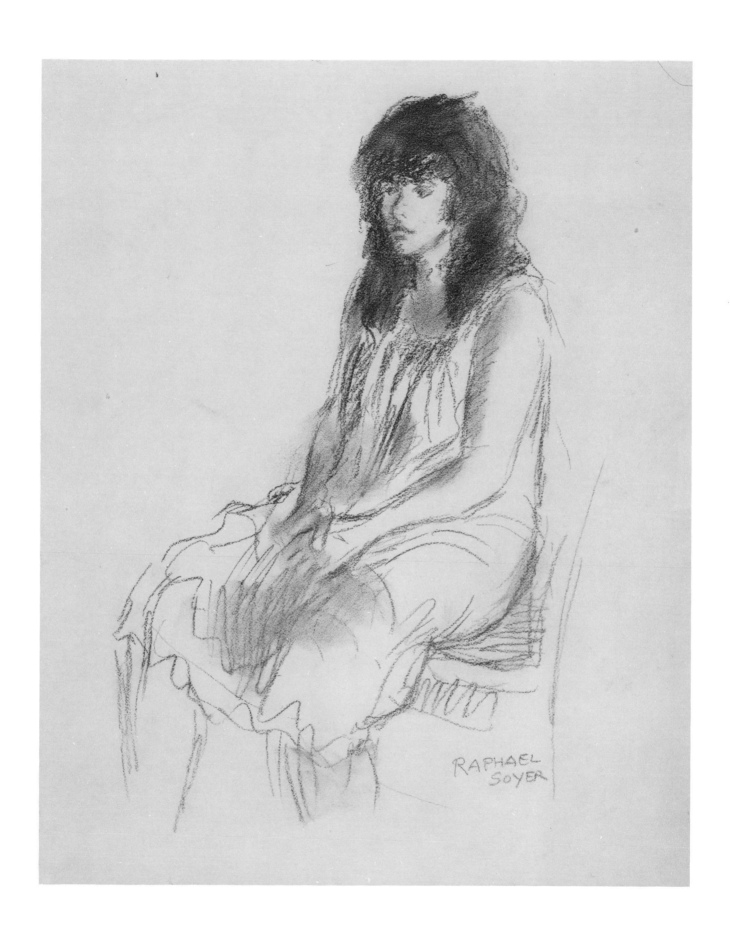

Seated Girl. 1970s. Charcoal; 24 × 19 inches.

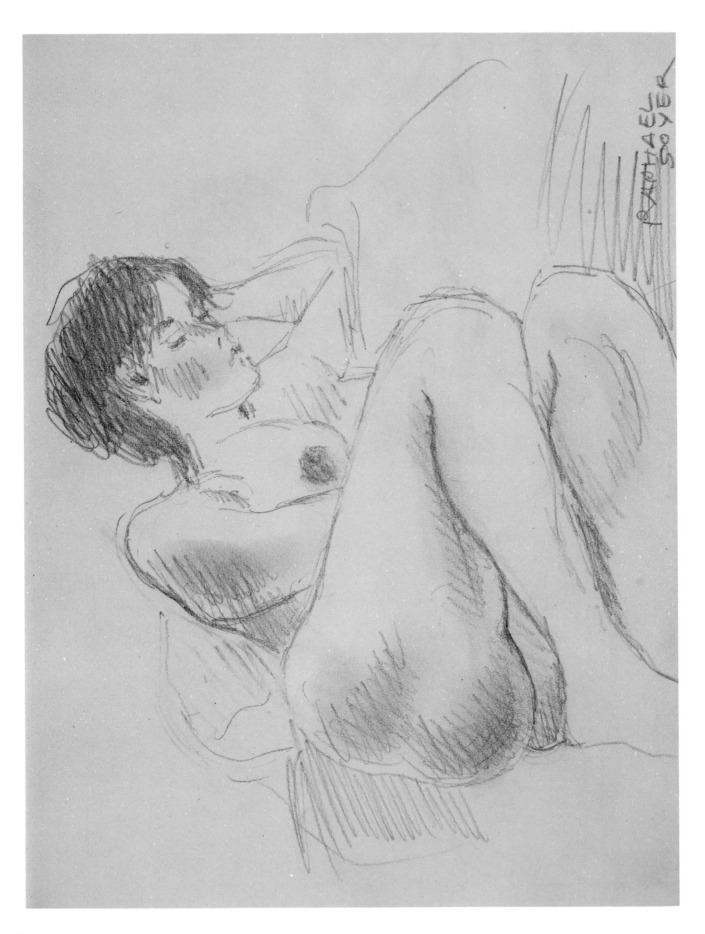

40

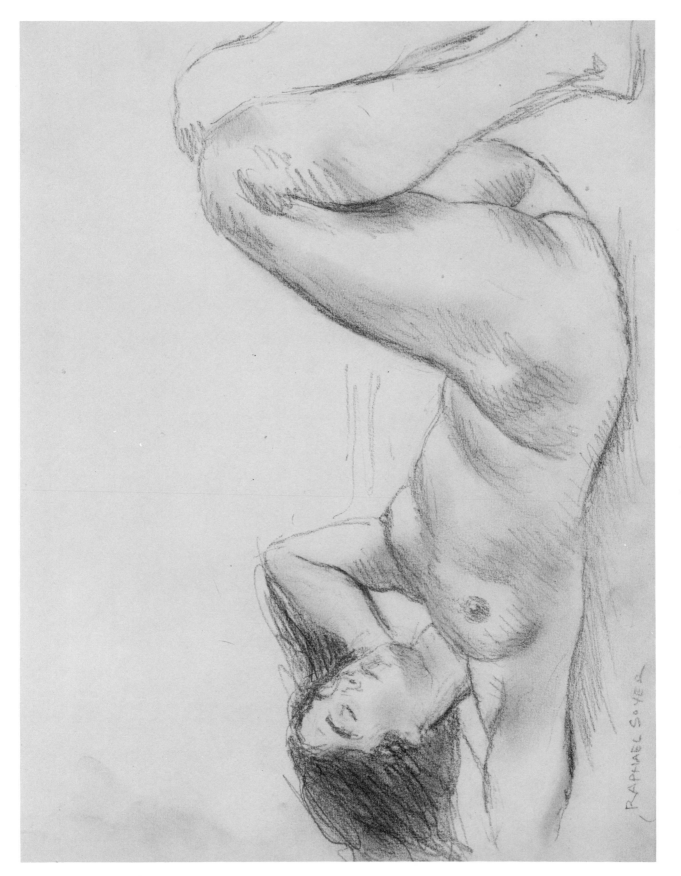

Top: Nude on Side, Knees Drawn Up. 1981. Pencil; 13⅜ × 10¼ inches. Bottom: Reclining Nude, Hands behind Head. 1980s. Pencil; 10¼ × 13⅜ inches.

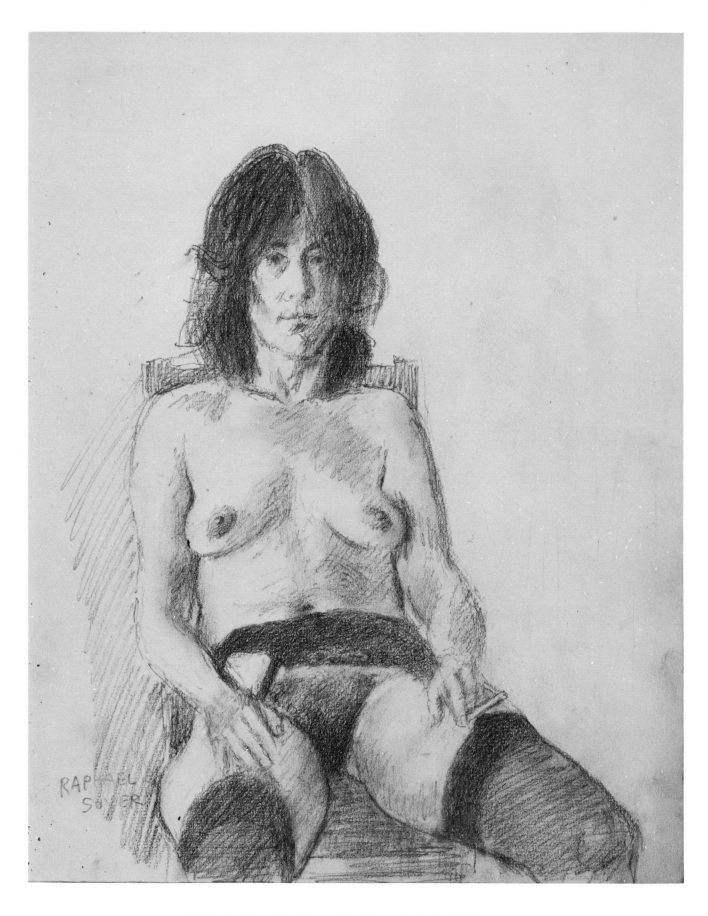

Model in Black Stockings. 1981. Pencil; 13⅜ × 10¼ inches.

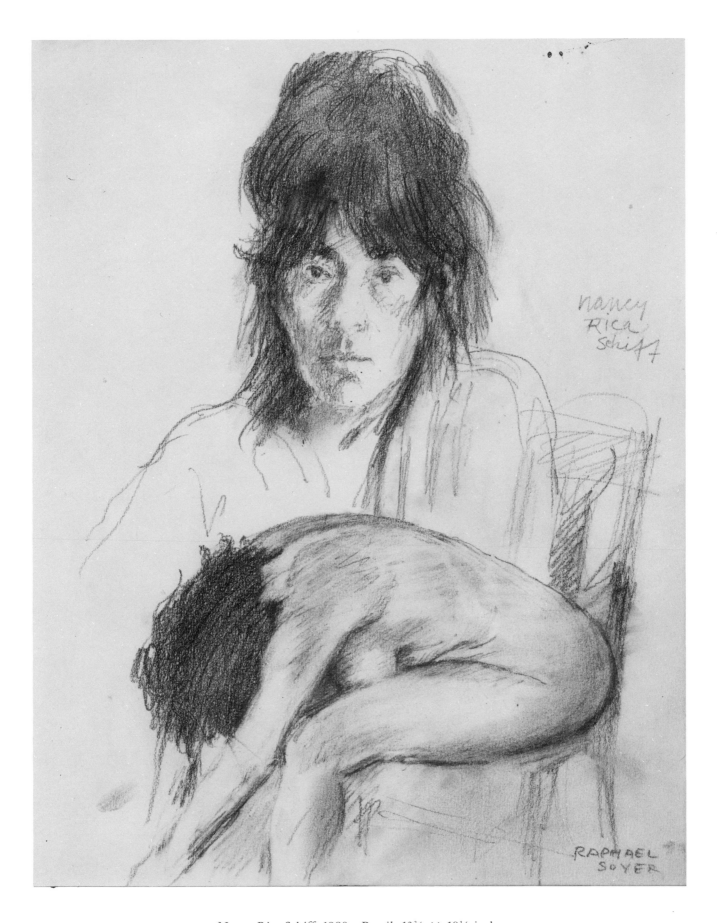

Nancy Rica Schiff. 1980s. Pencil; 13⅜ × 10¼ inches.

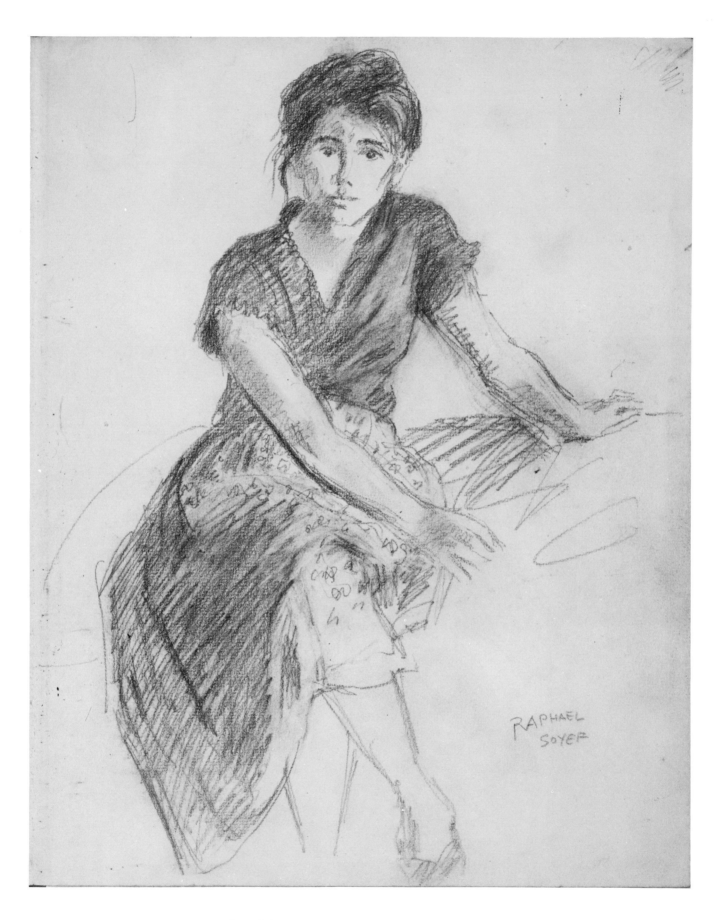

Seated Girl. 1980. Pencil; 13⅜ × 10¼ inches.

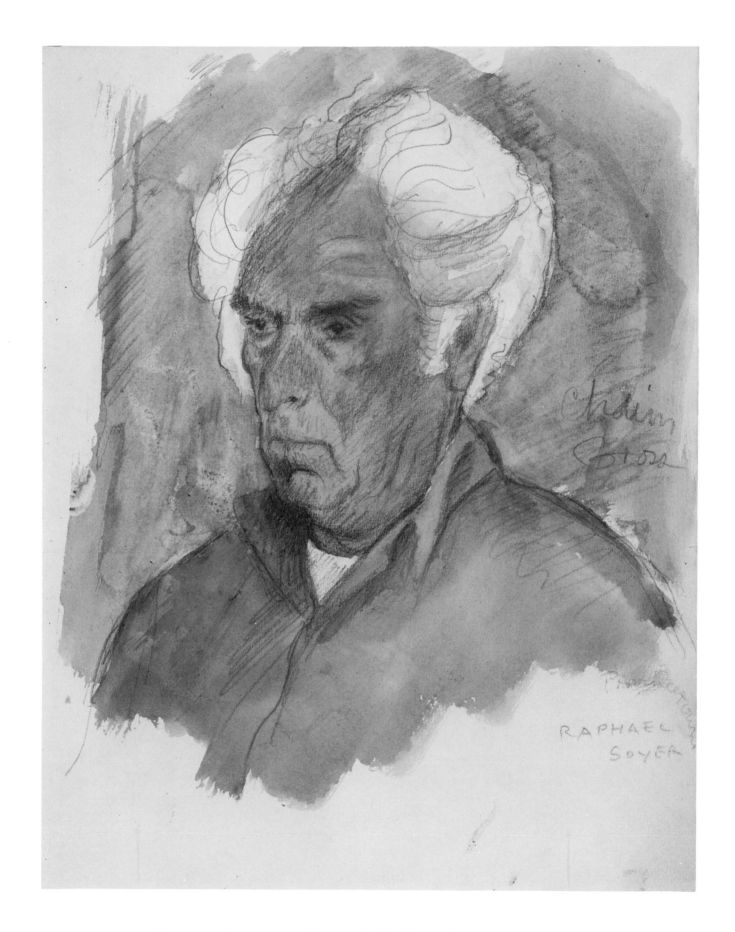

Chaim Gross (Provincetown). 1980s. Pencil and watercolor; 13⅜ × 10¼ inches.

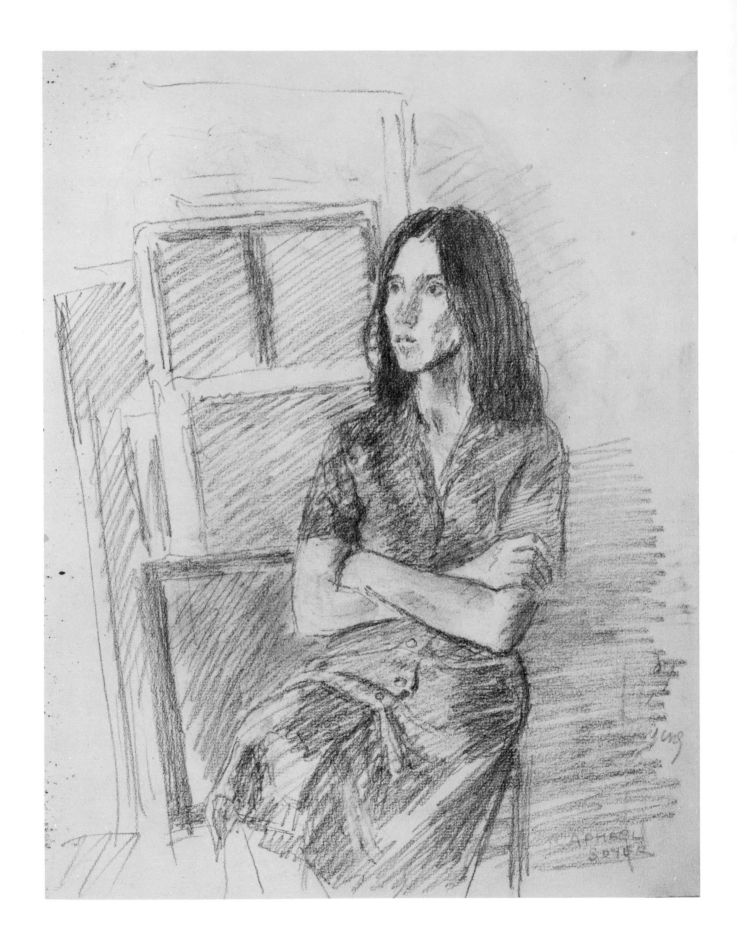

Seated Woman in Studio. 1981. Pencil; 13⅜ × 10¼ inches.

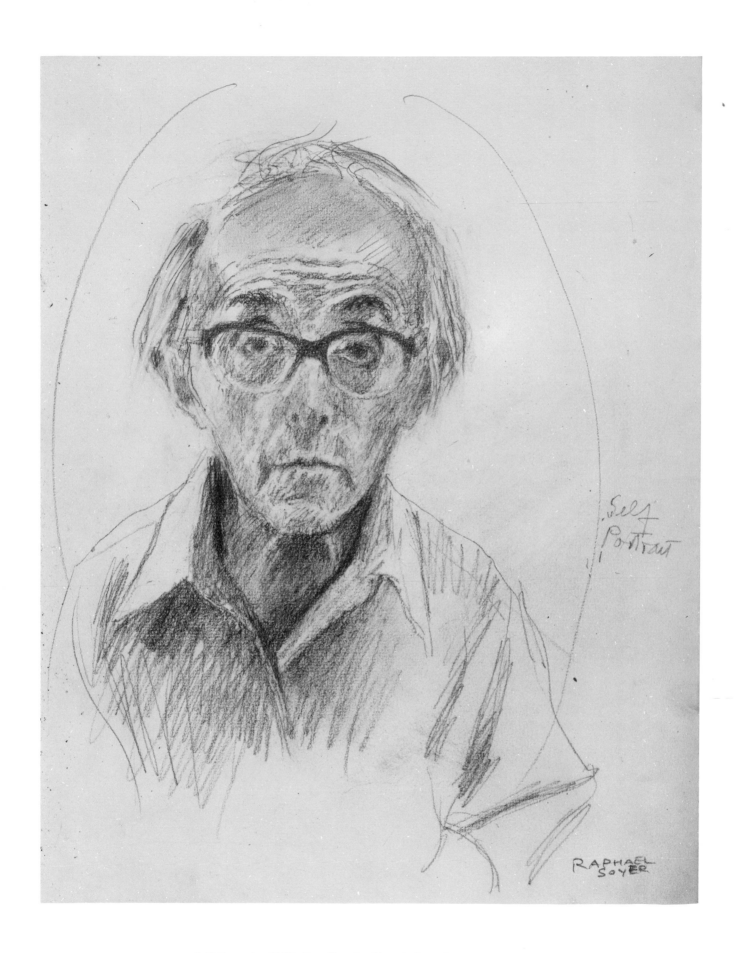

Self-Portrait. 1980. Pencil and white chalk; 13⅜ × 10¼ inches.